Copyright 2012 by Ben Dallas
All Rights Reserved
Printed in the United States of America

Dallas, Ben
ATTACHMENTS

(AntiPress)

ATTACHMENTS – 2011/2012

A series of constructed and painted works composed of an antique frame, as found, with painted image and altered white panel. Works are all less than 24" in largest dimension, acrylic media, and manufactured materials.

The form art takes is always more interesting than anything it's about.

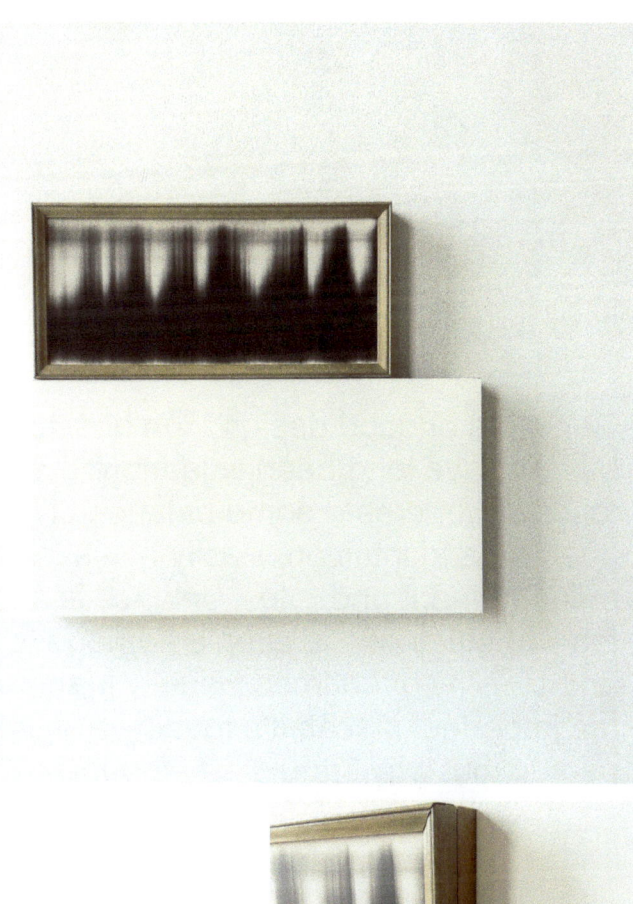
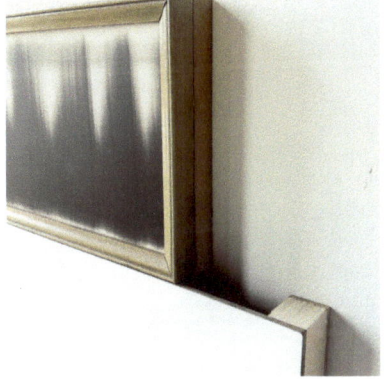

Concepts of good design, composition, and beauty have long been little more than attempts to isolate or create some balanced condition by analysis and intuition. Easily achieved through measurement and rules, balance is an all too familiar strictness, a simple homage to gravity and stability oftentimes visually inappropriate for the imperfect places it's found - a significant pursuit, but why should art stop there?

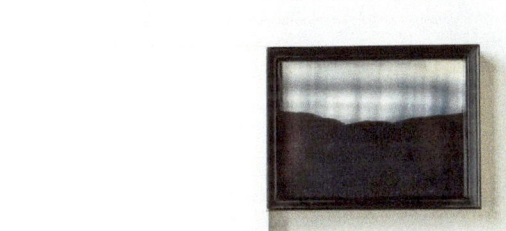
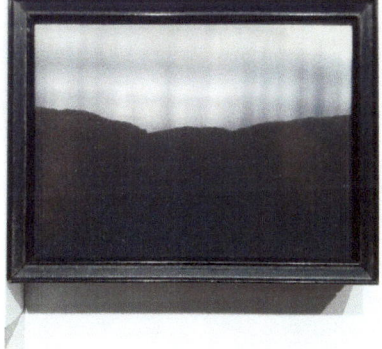

The challenges presented by questionable and taxing appearances, the awkward and new, have the potential to reorient viewers to their own processes of perception and thought. Art brings us around to new relationships by what it demonstrates.

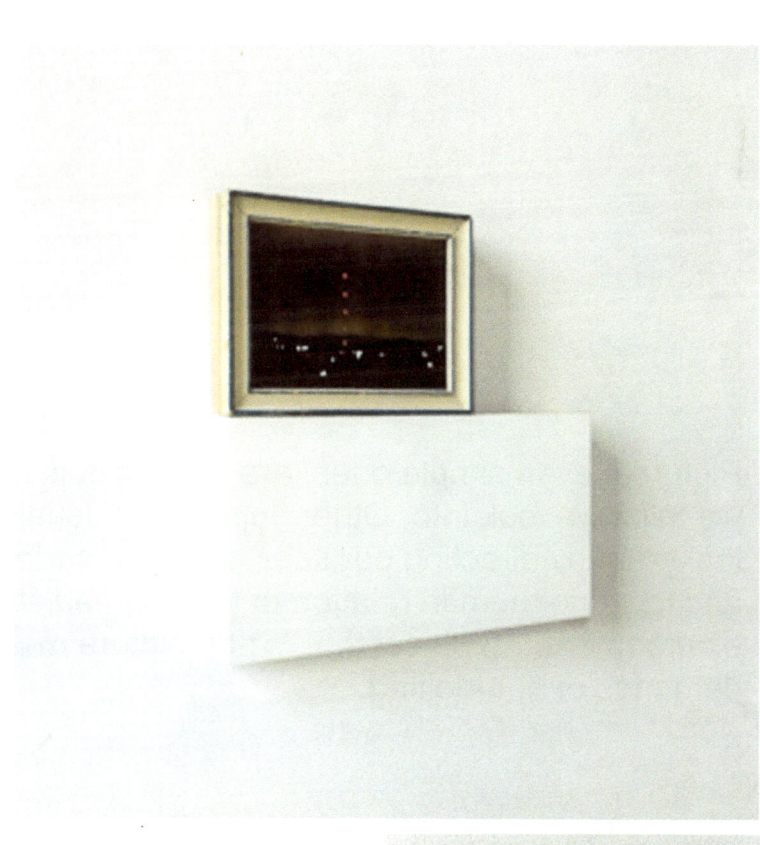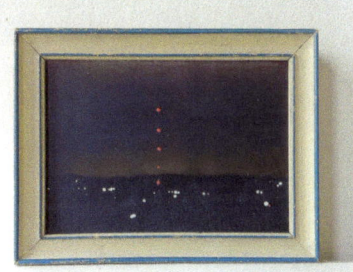

Pictures, even simple ones, are special objects we think we look into. Other objects are usually looked at by directing our seeing to their surfaces and locating them in relation to their immediate environment. An object that is part picture makes demands of our looking.

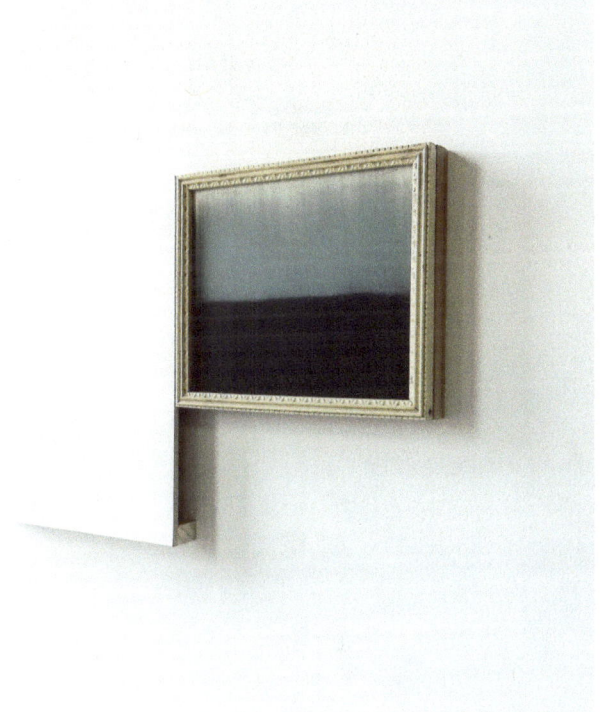

A whole is always more than a combination of its parts even when the parts have their own independent identities.

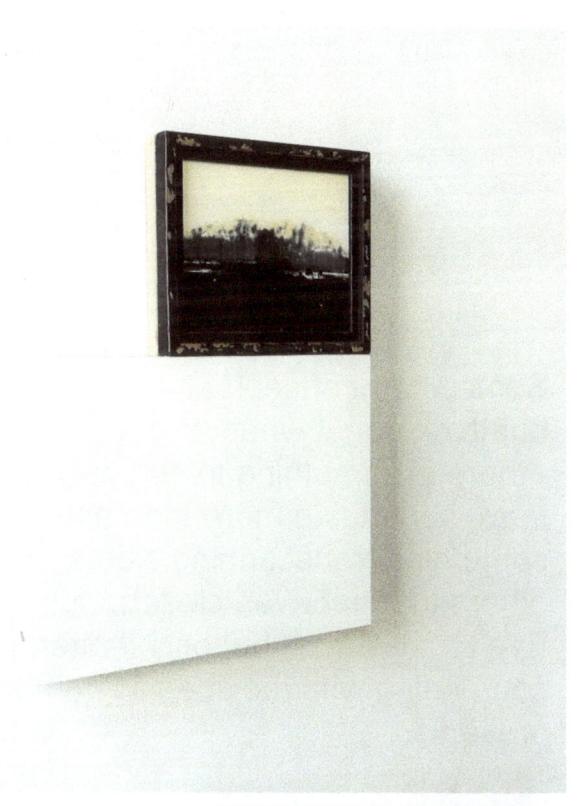
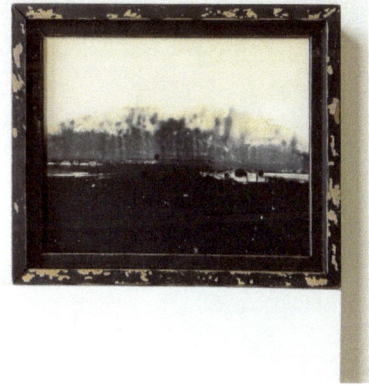

Somewhat "conceptual" because we can't help but think about what we see, but also "formalistic" - there is something to see only because it has/is form, something more than and before words, something transcending words, like these, and others that get even closer.
Eye candy? Yes, but only if attempting to evade contending with the specific demands its form presents.

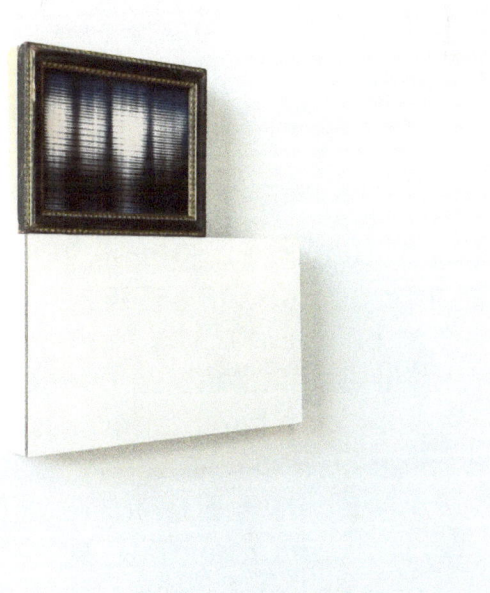
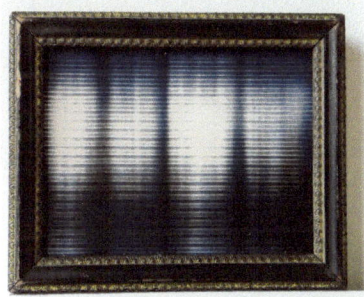

Serial images - a reason to look alike, actually, similar but not the same - a series of independent art objects related by materials and purpose – repetitious similarity suggesting some common focus or idea simultaneously embodied and missed by multiple attempts – autonomy insured by specific individual form while shared likeness suggests and magnifies some obvious connection never completely clear, their reason to be how they are.

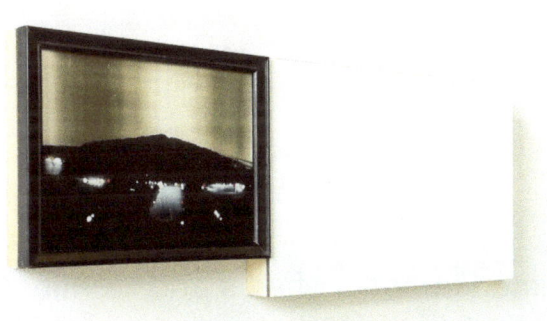
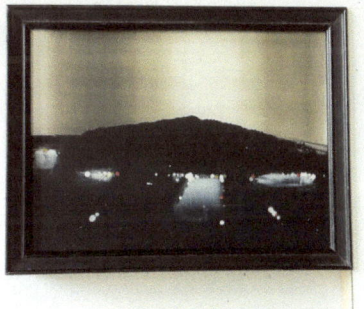

A framed image's effects and identity can be altered by the part it plays in a mix with other objects even when its role there is that of a framed picture.

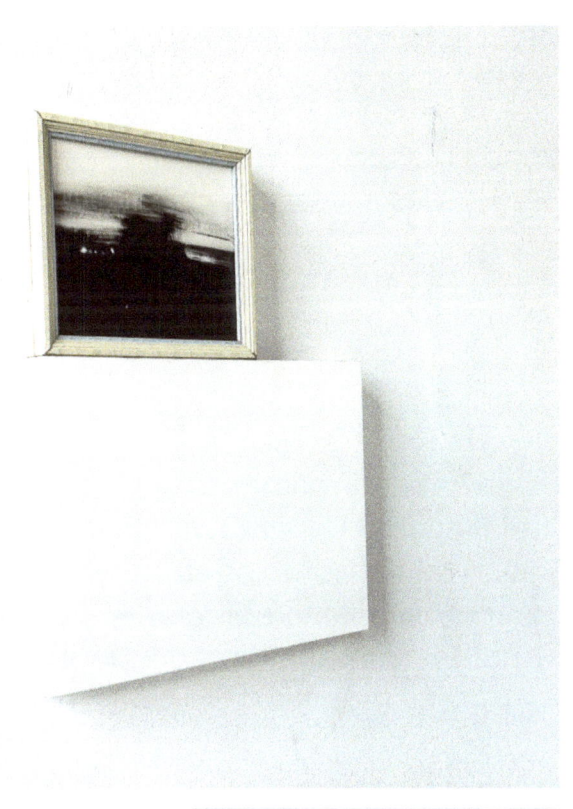
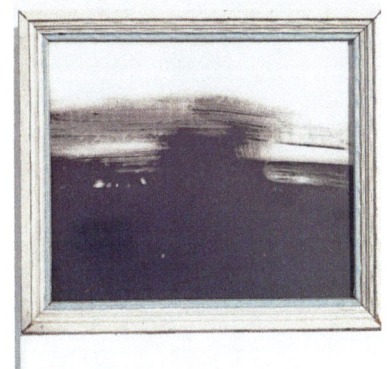

Designing or composing is easy because formal relationships are inevitable in all things seeable - everything "goes together" when put together. Of course, liking some specific combination is another matter entirely, a personal one.

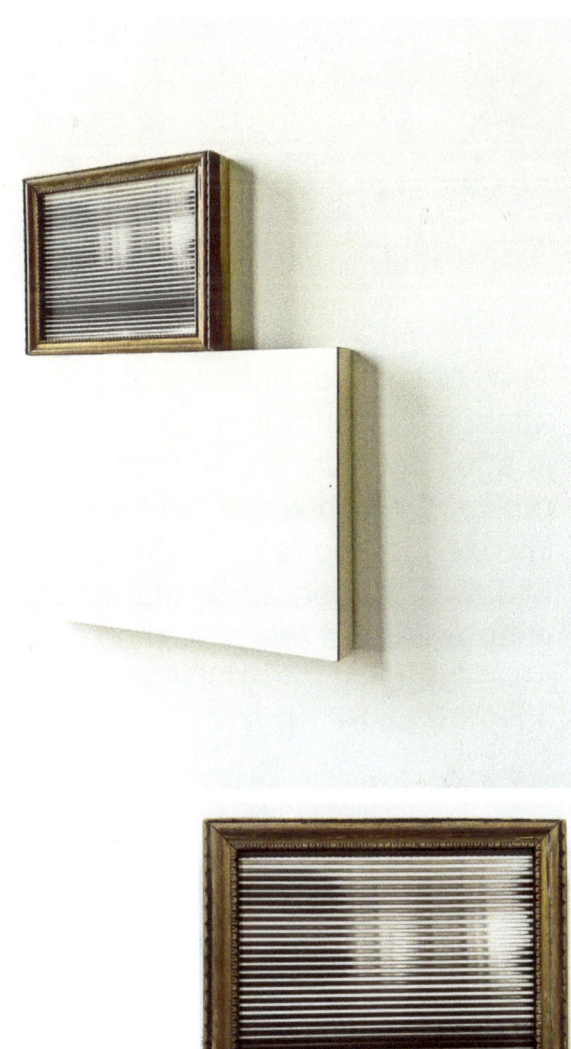

The subjects identified in illustrative pictures attest to our prior knowledge, while non-objective images possibly represent and signify aspects of reality of which we're not initially aware – new knowledge and relationships we are directed to find as a consequence of the experience of such images. As we are prompted by new imagery to reveal equivalents in the world, reality expands as it conforms to art.

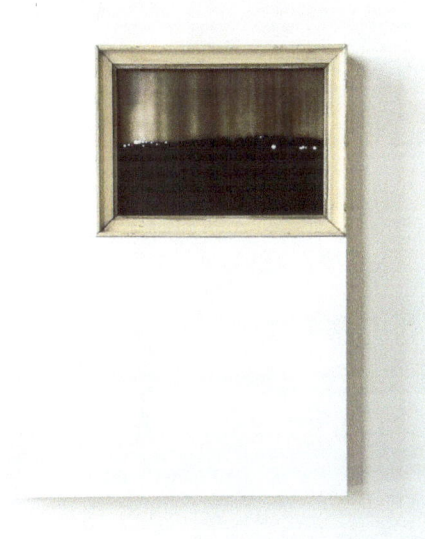
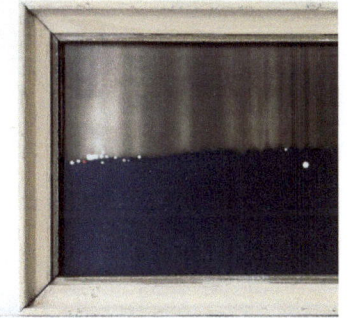

The space an antique picture frame confines is also old until filled with something not of its time.

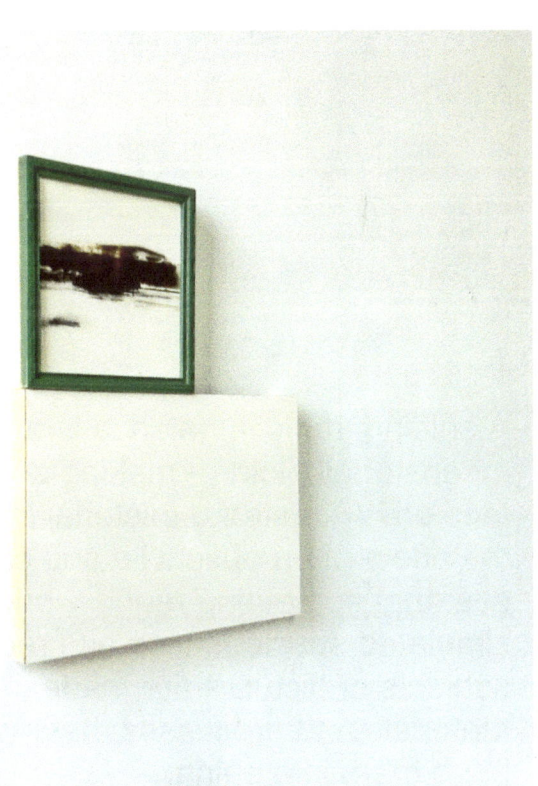
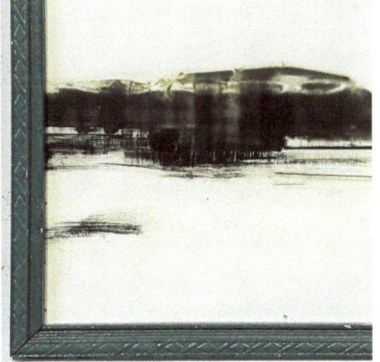

A shifting ironic imbalance is experienced by means of all picture- making as reality and illusion face off. With strong, pictorial images we are at the effect of an optical lie and can only know, not see, that something real is working to offer it - the simulated spaciousness and recognizable subjects of pictures are made present by actual materials and processes that must disappear to bring them into being.

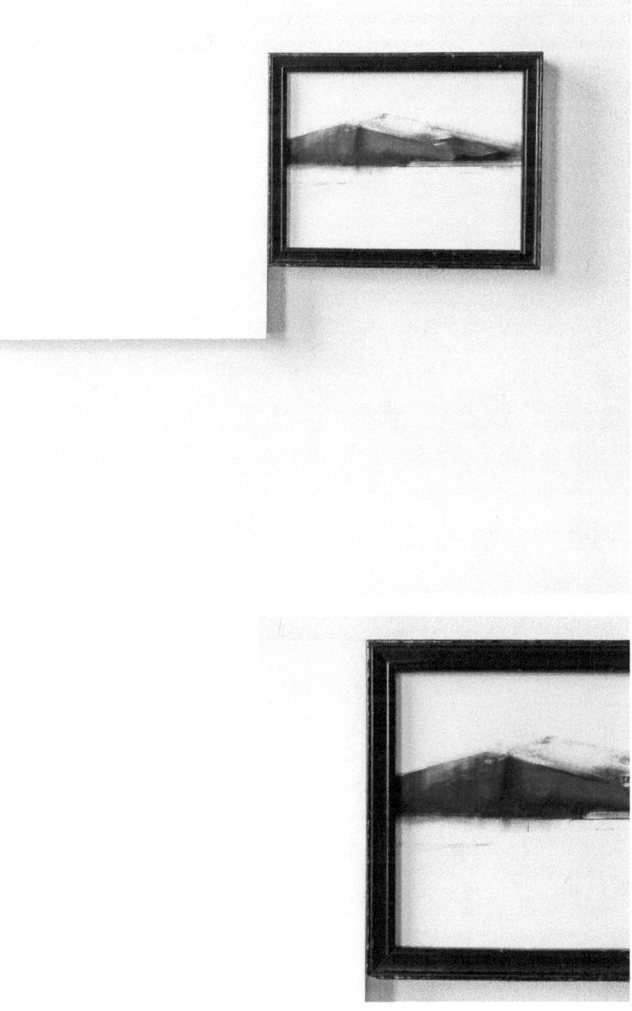

BEN DALLAS/ART
1117 W. Lake St. Chicago, IL. 60607 bendallas.com

www.ingramcontent.com/pod-product-compliance
Lightning Source LLC
Chambersburg PA
CBHW051112180526
45172CB00002B/876